Painting Birds in Gouache

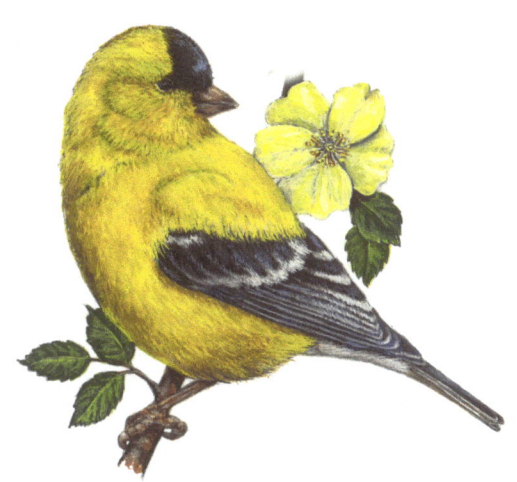

Written and Illustrated
by
Sandy Williams

© Sandra L. Williams 2011

Painting Birds in Gouache

Index

Introduction ... 1

Gouache .. 2

Materials List ... 3

About This Course ... 4

Before You Begin (Health & Safety) ... 5

Blending Exercise -- Feather .. 6

Notes ... 7

Blending Exercise - Owl Eye ... 10

Black Capped Chickadee .. 12

American Goldfinch ... 20

Blue Jay .. 28

Notes ... 38

Wrapping Things Up .. 39

Notes ... 40

Introduction

Welcome to "Painting Birds in Gouache." This course is designed to show you, in step by step demonstrations, the techniques of using gouache to paint feathers, beaks and flashing eyes.

I was introduced to gouache during my college years at Indiana University when it was used in a design class. We used it only for large, flat areas of color and it wasn't until years later that I began exploring other possibilities and finding out what the medium was capable of -- anything from intense, flat color to delicate, fleeting shades and minute detail.

The three birds in these demonstrations are common throughout most of the United States: the Black Capped Chickadee, the American Goldfinch and the Blue Jay. The goal of this course is to give you the basic knowledge of tools, materials and techniques so you can use gouache in furthering your depictions of any of the broad spectrum of bird life around you.

Gouache

Gouache is an opaque watercolor. The pigments are bound by a liquid glue, like Gum Arabic, and white pigment or chalk is added for more opacity. It has an almost suede like finish and lines painted with gouache can be very sharp. The colors can be brilliant or very subtle. It has a centuries old history and has been used for anything from illuminated manuscripts to modern commercial advertising work.

There are many advantages of using gouache. You don't have to deal with the odor, toxicity and slow drying time of oils. Acrylics dry very quickly and can't be reworked, while gouache paintings can be reworked months or even years later.

There are many brands of gouache available. I use mostly Winsor & Newton because it's easy to find and of good quality. Other brands are M. Graham, Holbein, Schmincke and Daler Rowney.

The first time you use gouache squeeze a small amount of color onto your palette. Even though you don't use it all up right away you'll be able to reconstitute it with water for later use. The only time this won't work is when you have a large area to cover. Use fresh paint for that or you'll get little lumps of undisolved paint in yur piece. If that happens brush them off and touch up.

Don't add a lot of water to the paint, or fill up the paint well on your palette with water. Water is added to the paint a little at a time by dipping your brush in water and then working it into one side of your spot of paint. The paint should have a creamy consistency. If you add too much water the paint will lose its opacity. The colors can be mixed in another well on the palette or, sometimes, directly on the painting.

One of the great advantages of gouache is that it's very "forgiving." If you find that a certain area is not working just paint over it and start again.

Start by squeezing out spots of paint about this size

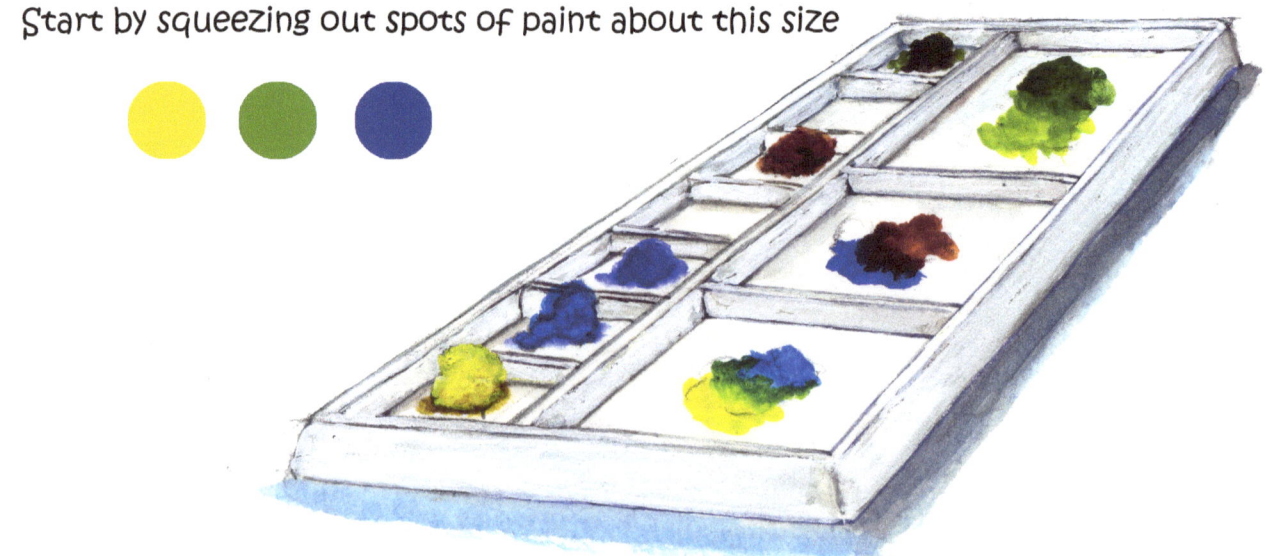

Materials List

PENCILS -- I generally use a softer pencil, like a 4B, to draw with but use whatever you're comfortable with. Just make sure that you don't make your marks so hard that they're hard to erase. I use a kneaded eraser because it won't leave little crumbly bits of material that have to be brushed off.

PAPER -- I recommend using hot press watercolor paper, preferably 140 #, although a little lighter weight would be OK, too. Some artists use illustration board, vellum or bristol. I use Arches 140# hot press because it has a nice, smooth surface to make detailing easier and crisper looking. Experiment and try some different papers. One half standard size sheet should be plenty for this course.

PALETTE -- It should be white so you can see exactly what color you're mixing. If you don't have a palette a white paper plate works fine. It's just a little harder to transport wet paint if you have to move around.

WATER CONTAINER -- Use whatever you have on hand. At home I use 5 ounce disposable Dixie cups or old cat food containers (properly washed!).

TRANSFER PAPER -- Depending on how you transfer your images you may or may not need some plain tracing paper. An 11" x 14" sheet folded in half should do. Cover one side completely with soft graphite.

BRUSHES -- You'll probably need three small watercolor brushes: a 4/0 small round, a #1 small round and a very small brush in the range of 18/0 or 20/0.

GOUACHE -- The nine tubes listed here will give you enough variety of colors to complete all the illustrations in this course. The brand I use is Winsor & Newton but that's not a requirement.

- Permanent White
- Olive Green
- Burnt Umber
- Burnt Sienna
- Yellow Ochre
- Primary Blue
- Ivory Black
- Ultramarine Blue
- Spectrum Yellow

About This Course

Throughout this course you'll see the word "blend" over and over again. I can't stress enough how important it is to learn this technique. If your strokes aren't blended a bit they'll look too hard edged and your bird won't look soft and realistic. The first two exercises are geared toward practicing blending. After you make your strokes, take a damp brush and gently run it over the strokes, parallel to them, to soften them and blend the color into the layer underneath them. This will also change the color.

Although there's a tiny bit of background included with each bird (a branch, a flower or berries) we won't be spending much time on them. This way we can concentrate on completing the bird.

We'll be working on the birds a section at a time (the head, tail, wing, etc.), but this is for ease of demonstration only. In reality you may not complete one section before you start on the next. Find out what works best for you.

A note about color: Don't worry about getting exactly the same colors as in the demonstrations. Color can be fleeting. Look at a Blue Jay on a cloudy day and then look at the same bird shining in the sun. One day he could be a dull blue gray and the next a brilliant, eye stopping blue. There's not always a "right" color.

Pay attention to the values in your paintings. Value is the lightness or darkness of your paint, and without a good range of values your painting will look a bit boring, without, well. . . sparkle! Some samples of the value scales you'll be using are below.

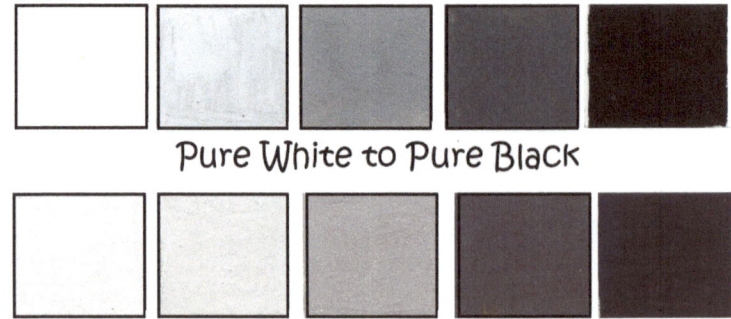

Pure White to Pure Black

Burnt Umber/Ultramarine Blue: light to dark

Great Blue Heron

Before You Begin

Here are a few tips on health and safety.

BE AWARE! Some of the pigments we work with are poisonous. Visit a site like http://www.ci.tucson.az.us/arthazards for specific information on the pigments or processes you use.

For this course please remember three things.

1. Don't put the tips of your brushes in your mouth!

2. Wash your hands after painting before you eat.

3. Get up and stretch frequently. Besides loosening up your body you'll come back to your painting with fresh eyes and it will be easier to see the progress you've made and what has yet to be done.

Nuthatch

Feather -- Blending Exercise

Color used: Ivory Black, Permanent White, Primary Blue

(1)

Transfer this image to your watercolor paper. Using Black, paint over the lines so they won't be lost when you start painting the underpainting. Don't worry about getting the lines exactly even at this point.

(2)

Underpainting --
With a thin consistency of gouache, paint the tip of the feather dark gray, stroking in the direction of the barbs. Paint the rest of the feather with a thin wash of black, always stroking in the direction of the barbs, and trying not to lose the guidelines you painted previously.

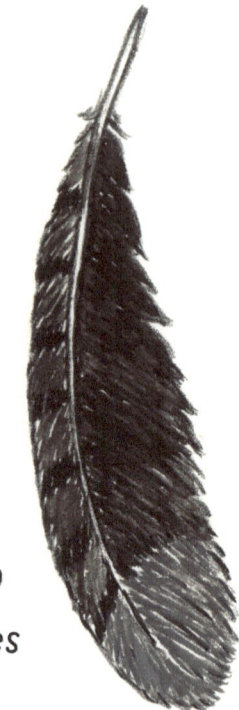

(3)

With a mixture of Primary Blue with a little White added, use your liner brush to paint the barbs on the right side of the quill.

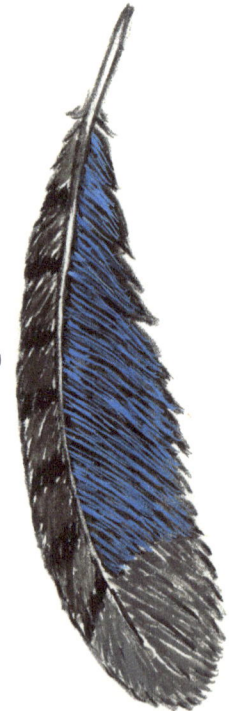

(4)

With a damp brush, blend your strokes to soften and darken them.

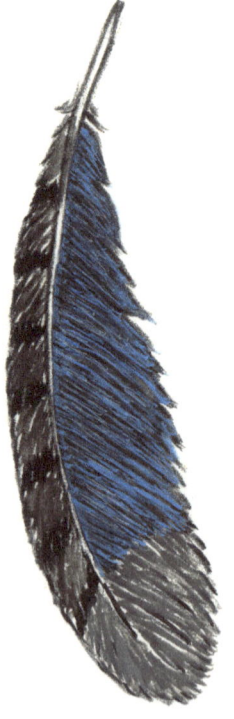

Feather -- Blending Exercise

(5)

With pure White, paint another layer of barbs.

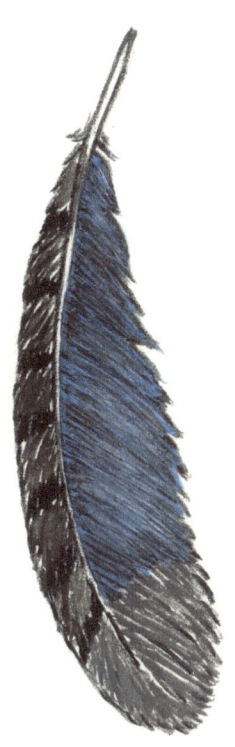

(6)

With a damp brush, blend the strokes. To complete this section of the feather, mix Primary Blue with Black and restate some of the narrow black lines.

(7)

Using pure Primary Blue, paint in the blue sections between the black bars on the left side of the quill. Paint your strokes in the direction of the barbs.

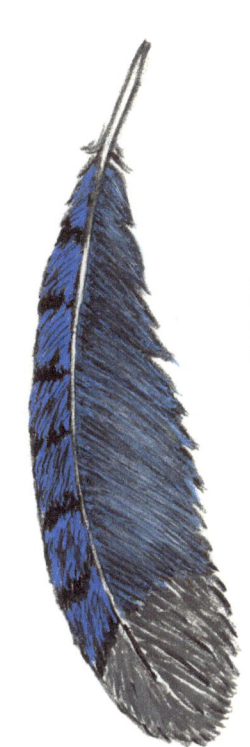

(8)

Begin layering on strokes of thick, White gouache.

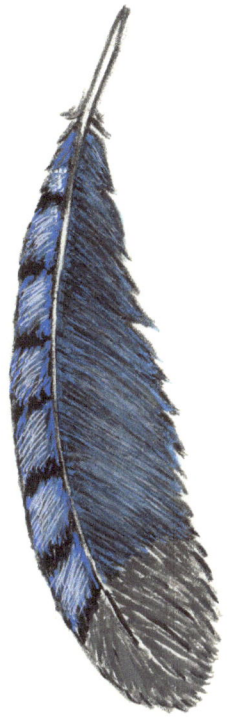

Feather -- Blending Exercise

(9)
With a damp brush, gently blend your strokes. Add more White strokes and blend again. Remember to keep your strokes very narrow.

(10)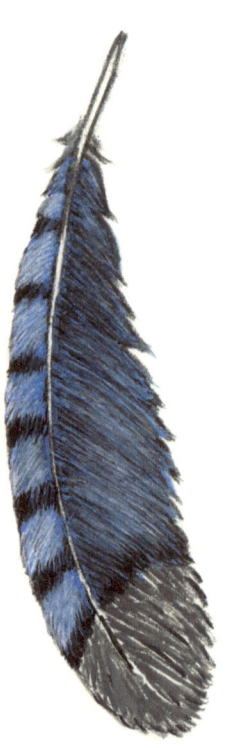
With Black, paint in the bars on the left side of the quill. Using White mixed with a touch of Primary Blue, paint some tiny strokes over the black bars to break them up.

(11)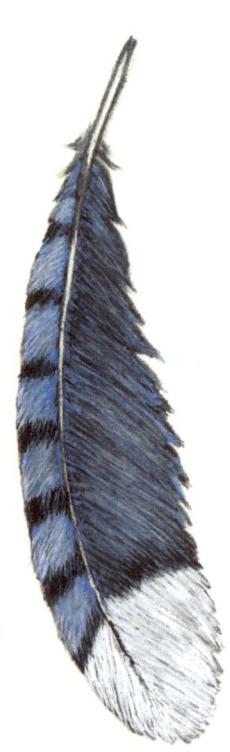
With thick, pure White gouache, paint the tip of the feather, being careful to make your strokes in the direction of the barbs. Slightly blend where the white of the tip meets the black of the upper feather so there won't be a hard line.

(12)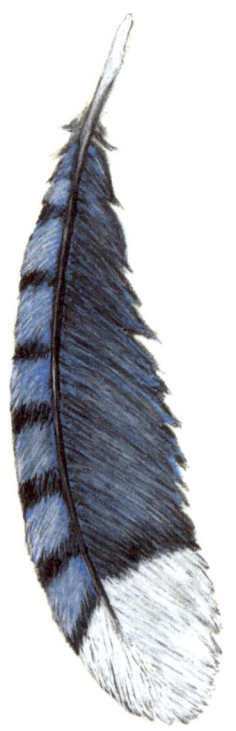
Paint the quill pure Black. Paint a narrow White highlight along its length. Blend it to show form. The quill tip should be White.

Notes

Great Horned Owl Eyes -- Blending Exercise

Color used: Ivory Black, Permanent White, Burnt Umber, Burnt Sienna, Ultramarine Blue, Primary Blue, Spectrum Yellow

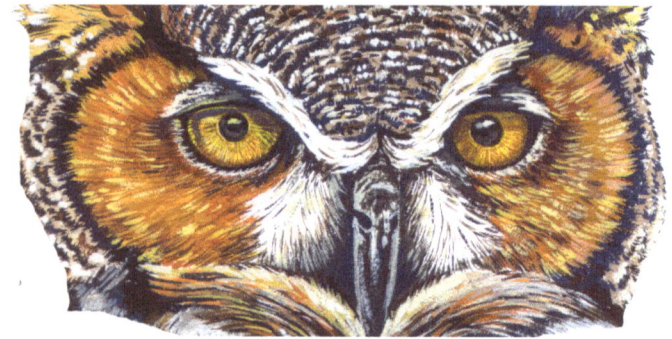

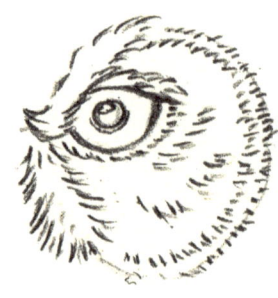

Use this black and white drawing to transfer the image to your drawing paper.

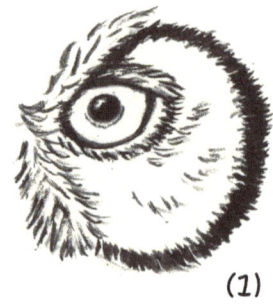

(1)

With Black, paint over your pencil lines so they won't be lost when you start layering on the gouache.

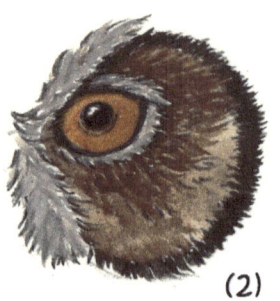

(2)

Underpainting -- Use thin paint to paint the iris Burnt Sienna, the area around the eye Burnt Umber and the white places a medium gray (made of a mixture of White plus a little Burnt Umber and Ultramarine Blue).

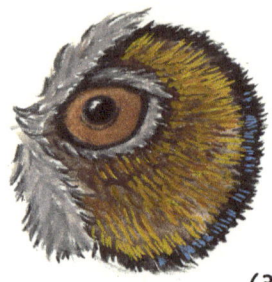

(3)

With Primary Blue mixed with a little White, paint short strokes radiating outward on the black circle on the outside edge. With Burnt Sienna mixed with Primary Yellow, paint short strokes in the larger area just inside the black outside ring. Make the strokes in the direction of the feather pattern and lift up your brush at the end of each stroke to make a fine point overlapping the black ring.

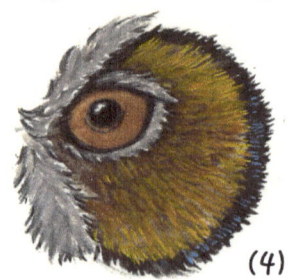

(4)

With a damp brush, barely wet, blend by gently stroking your brush along your painted lines. Blend just enough to take the hard edge off the strokes. The color will darken because the color from the underpainting will mix with it.

Great Horned Owl Eyes -- Blending Exercise

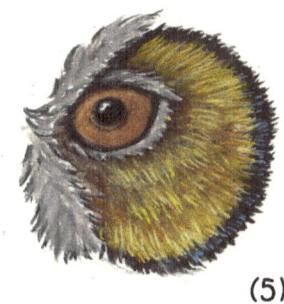

(5)

With White tinted with Spectrum Yellow, paint the final layer on this area around the eye. Use short strokes going in the direction of the feathers. This layer will look too light until you blend it into the layer below. If you blend too much, just add more white and then soften the stroke again with a damp brush.

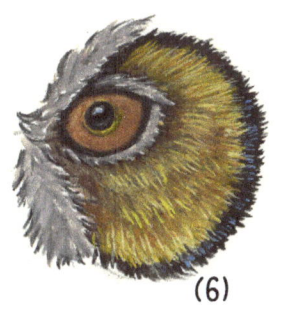

(6)

Iris -- For the highlight in the pupil, use Primary Blue mixed with White to paint a highlight on the upper part and a curve of reflected light underneath. Blend them in a little. Then use White to restate the upper highlight and add a sparkle to the eye. Paint a tiny yellow circle around the pupil.

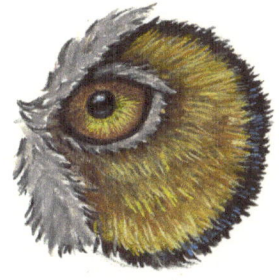

(7)

With Spectrum Yellow mixed with a little White, and using a very light touch, paint lines in the iris radiating out from the pupil to the outside edge. Blend slightly. With Burnt Umber make tiny lines radiating out from the center on the upper half of the iris for the shadow.

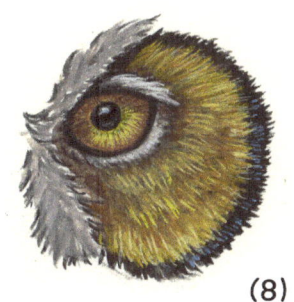

(8)

With pure White paint in the feathers just above and below the eye. Be sure to blend the strokes together a little.

With White, paint in the feathers next to the beak and the upper left of the eye. Let some of the underpainting show through. Blend slightly.

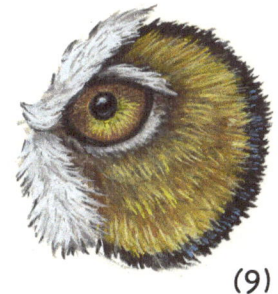

(9)

11

Black Capped Chickadee

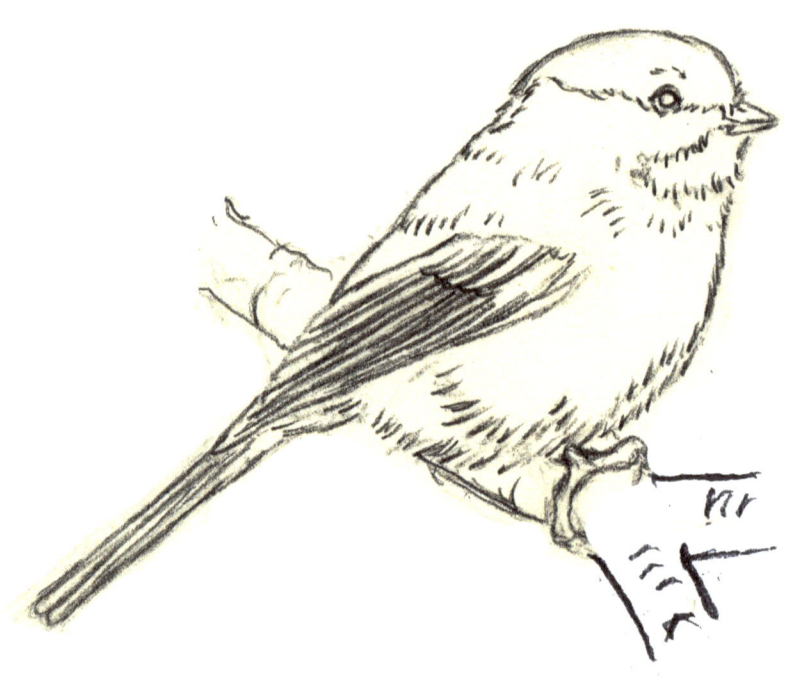

Use this page to transfer the image
over to your watercolor paper.

Black Capped Chickadee — Branch

Colors: Permanent White, Ivory Black, Burnt Umber, Ultramarine Blue, Yellow Ochre.

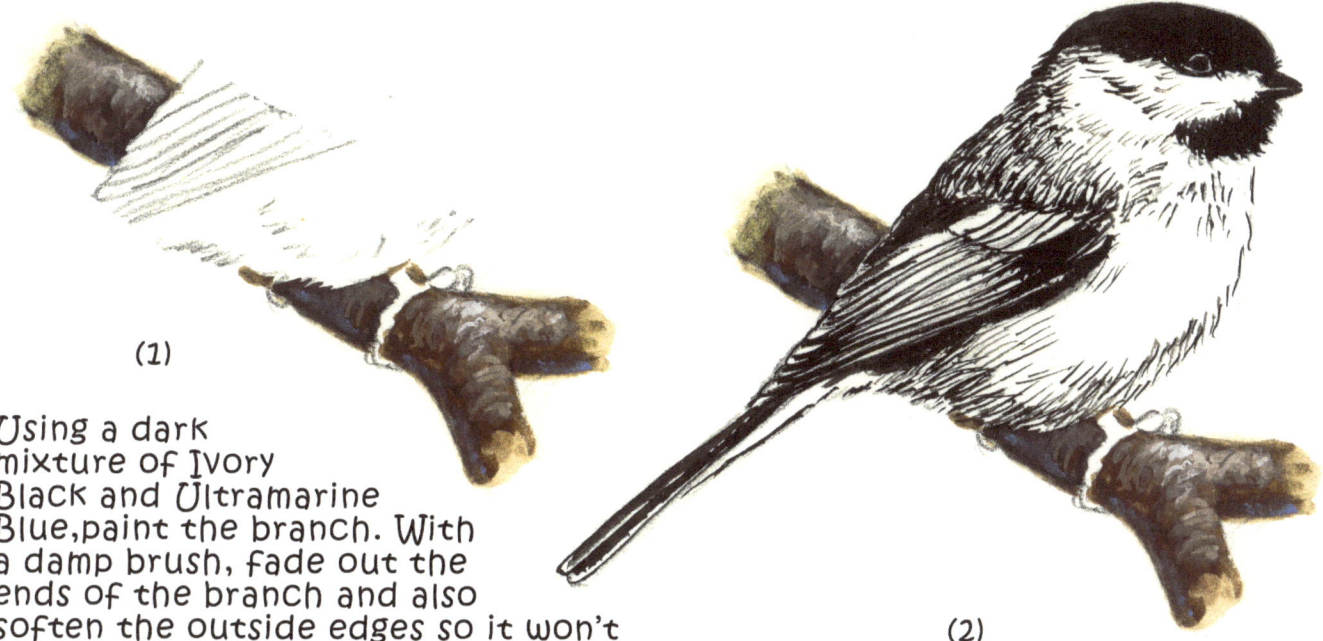

(1) Using a dark mixture of Ivory Black and Ultramarine Blue, paint the branch. With a damp brush, fade out the ends of the branch and also soften the outside edges so it won't look pasted on the paper. To detail the branch, use white and have your strokes curve around the upper part of the branch, following the form. With a damp brush, blend the white into the brown. Blend just enough so that the white turns a light brown. Leave a few small lighter areas for highlights or add them back in after you blend. With Ultramarine Blue mixed with White, paint reflected light on the underside of the branch. Blend it in with a damp brush so that you can barely see it.

(2) With pure Ivory Black, paint in the black areas of the head, wings and tail. Also, using narrow strokes, start painting in the feathers, making sure your strokes go in the direction of the feather pattern.

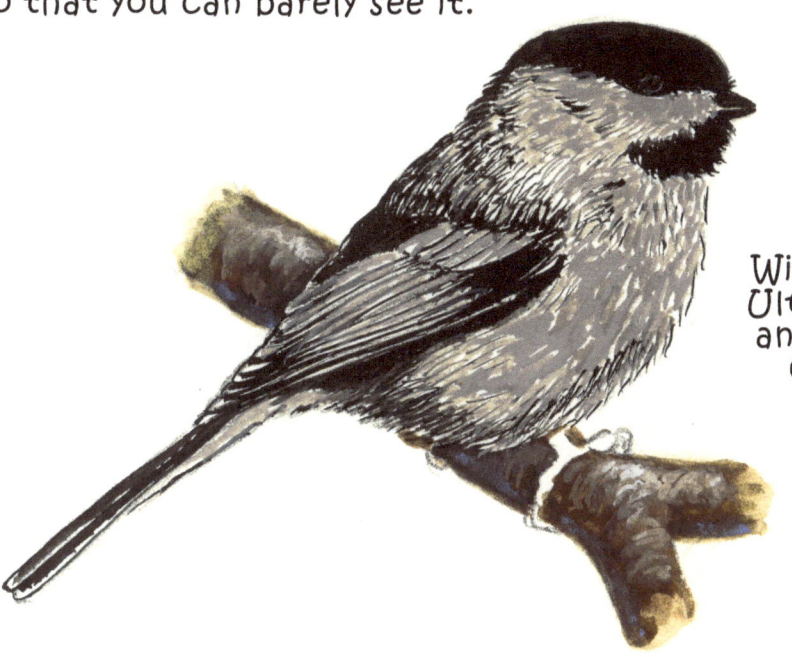

(3) With a medium gray mixture of Ultramarine Blue, Burnt Umber and White, paint over the rest of the white of the paper.

Black Capped Chickadee — The Head

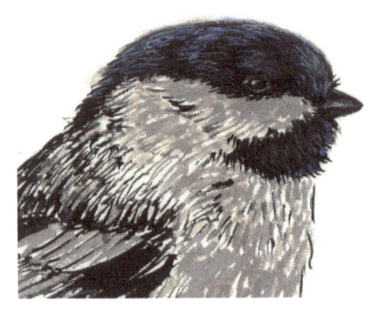

(4)

With a light gray (a mixture of White tinted with Burnt Umber and Ultramarine Blue), paint the faint highlights on the eyes. Gently blend the lines a little.
Again using a light gray, almost white, paint a small highlight in the pupil. With the same light gray paint short strokes in the cap, under the beak and along the edge of the beak where it opens. Gently soften all the strokes and the outside edges so the head won't look pasted on the paper.

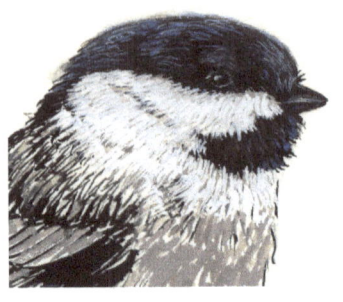

(5)

With pure white, paint short strokes, layer upon layer, in the white portions of the feathers on the head. Some of the lower layer of gray will mix with the white making it a light gray when you blend. In some places let the lower layer of gray show through. And in some places paint on enough white so that it actually stays white.

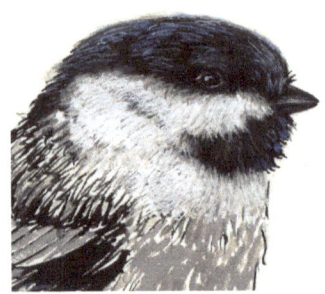

(6)

With a damp brush gently soften your strokes. Slightly blend the areas where the black meets the white. If you blend too much and lose some of the black or white, just add more gouache and blend again.

Black Capped Chickadee

The Chest and Underbelly

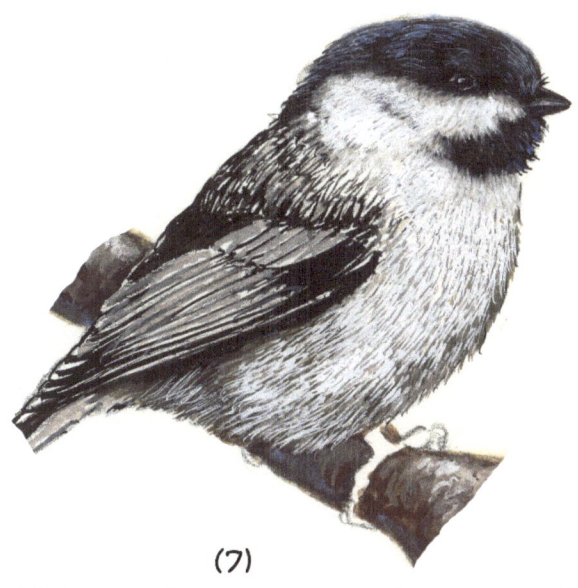

(7)

Using a dark gray (a mixture of Burnt Umber, Ultramarine Blue and White), paint short strokes in the shadow areas of the chest and underbelly. Then with pure white, paint short strokes in the lighter areas of the breast. Don't completely cover up the lower layer of gray.

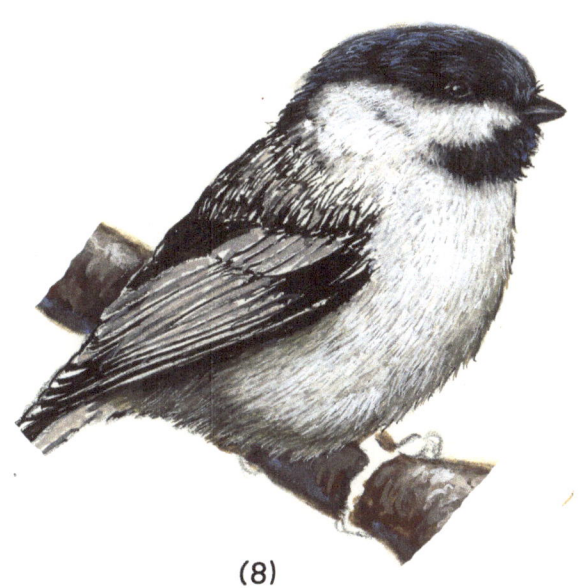

(8)

With a damp brush gently blend your strokes together. Some of the gray will mix with the white. If there are sections that get too dark, just add more short white strokes and blend again.

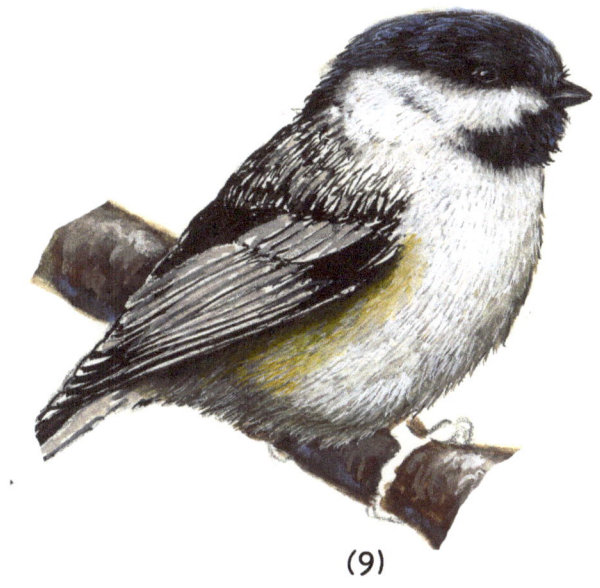

(9)

With Yellow Ochre mixed with White, paint in the warm buff color below the wings. Gently blend the strokes into the lower white layer.

Black Capped Chickadee — The Tail

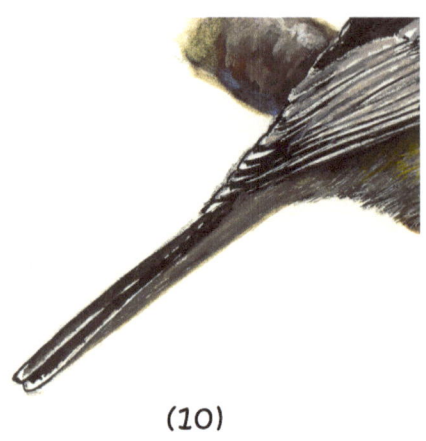

(10)

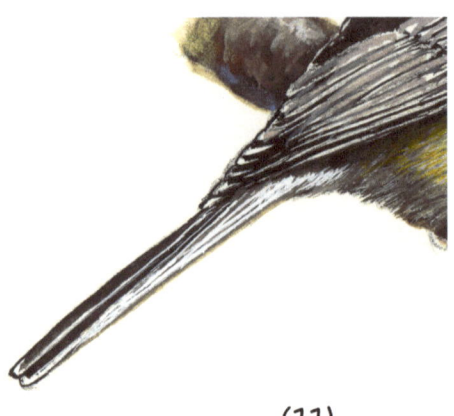

(11)

Using a dark gray (a mixture of Burnt Umber, Ultramarine Blue and White), paint in the lower portion of the tail, including adding some feathers where the tail meets the body. Soften the bottom edge with a damp brush so the tail won't look pasted on the paper.

With thick white gouache, paint in the edges of the tail feathers.

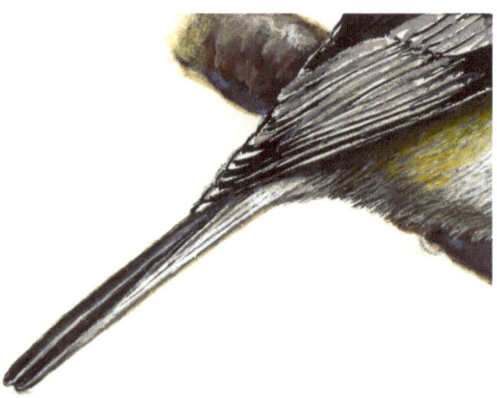

(12)

Carefully blend the dark and light areas of the tail feathers together, being careful not to blend too much and lose all your darkest darks or lightest lights. If you blend too much just add more black or white gouache and blend again. Don't forget to soften the outside edges so the tail won't look pasted on the paper.

Black Capped Chickadee — The Wings

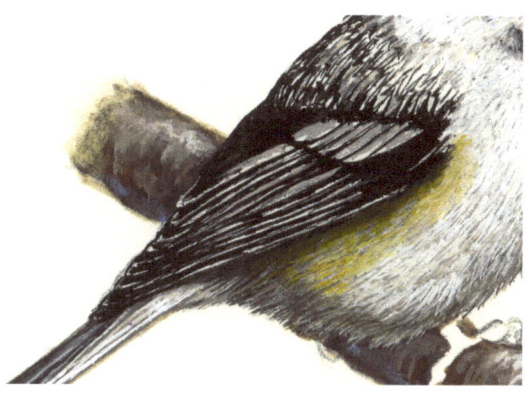

(13)

With pure black, darken the lines between the wing feathers. Make sure your lines curve along the contour of the wing. They shouldn't be perfectly straight or stiff looking.

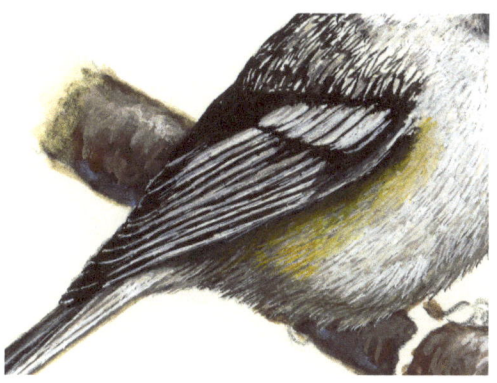

(14)

With pure white, paint in the light edges of the feathers.

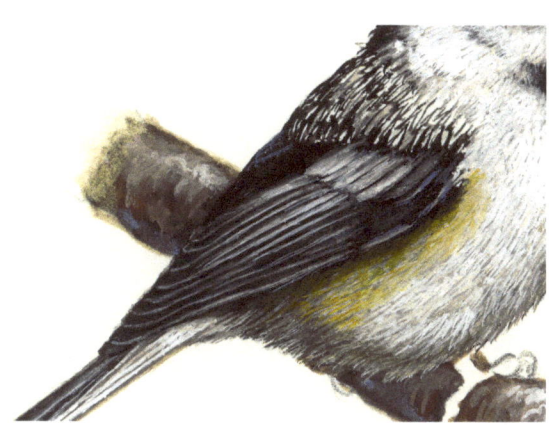

(15)

With a damp brush, gently blend the lights into the darks. These are very small areas and it will be easy to blend too much. Just add more white or black and blend again. This is a back and forth process. Be sure to make the left portion of the wing feathers darker as they curve toward the back of the bird, away from the light.

Black Capped Chickadee The Back

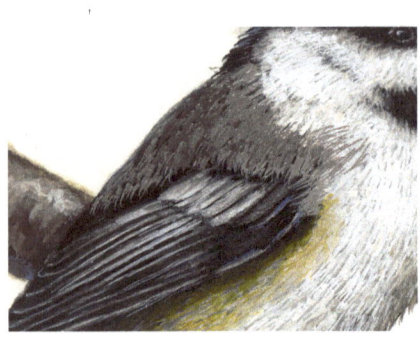

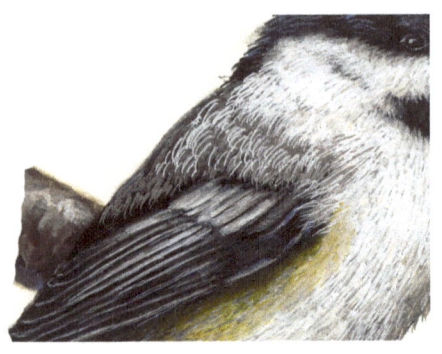

(16)

With short strokes, paint the back a medium gray (Burnt Umber plus Ultramarine Blue plus White). Let some of the dark value from underneath show through. Soften the upper edge of the back with a damp brush so it doesn't look pasted on the paper.

(17)

With short strokes, use White to paint in the top layer.

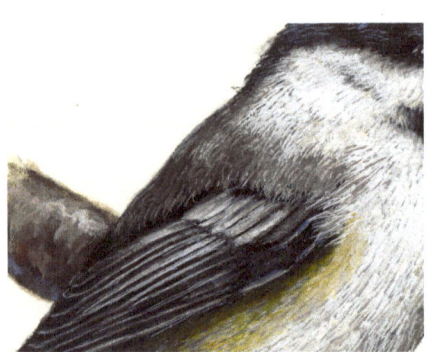

(18)

With a damp brush, blend the white in the shoulder and back into the lower layer of medium gray. It will turn light gray. The neck should remain white and be blended down into the gray on the shoulder.

Black Capped Chickadee The Foot

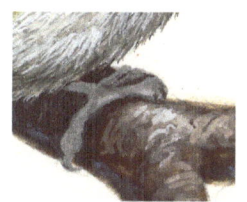

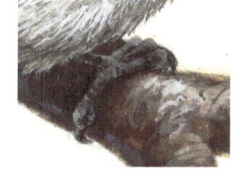

(19)

With a medium gray (Burnt Umber, Ultramarine Blue and White), paint the foot. You can barely see the left foot -- only a tiny bit of the back toe is showing but don't forget it. It can be painted in with a dark gray.

(20)

Detail the foot with pure Black blended into the gray. Add a few small highlights with white and blend them in a little. You may want to add more black to the branch so the foot will stand out.

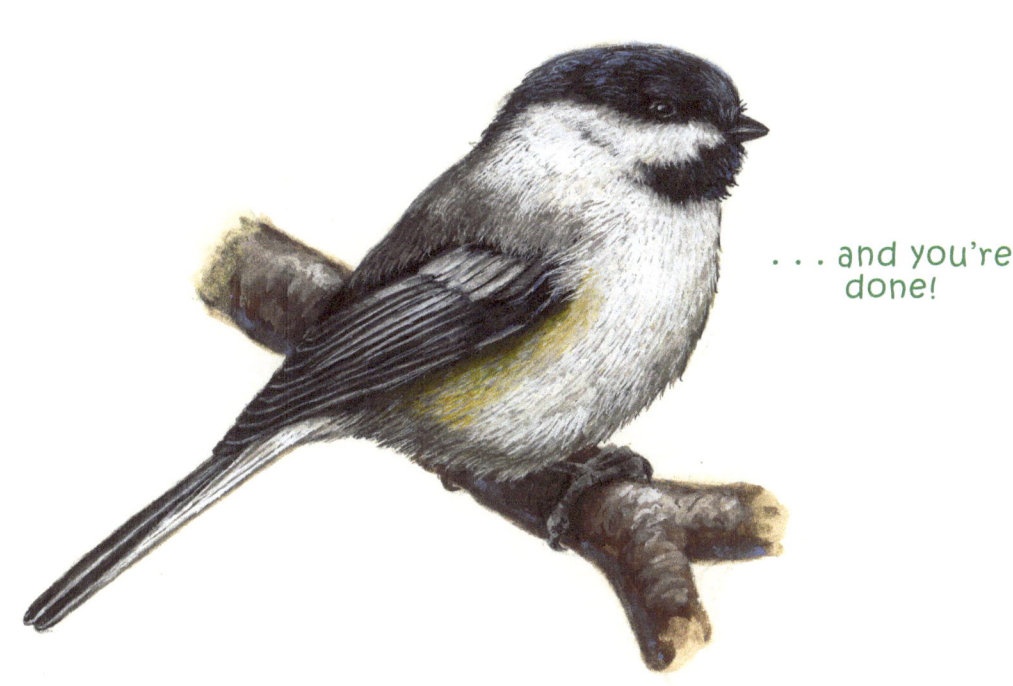

. . . and you're done!

American Goldfinch

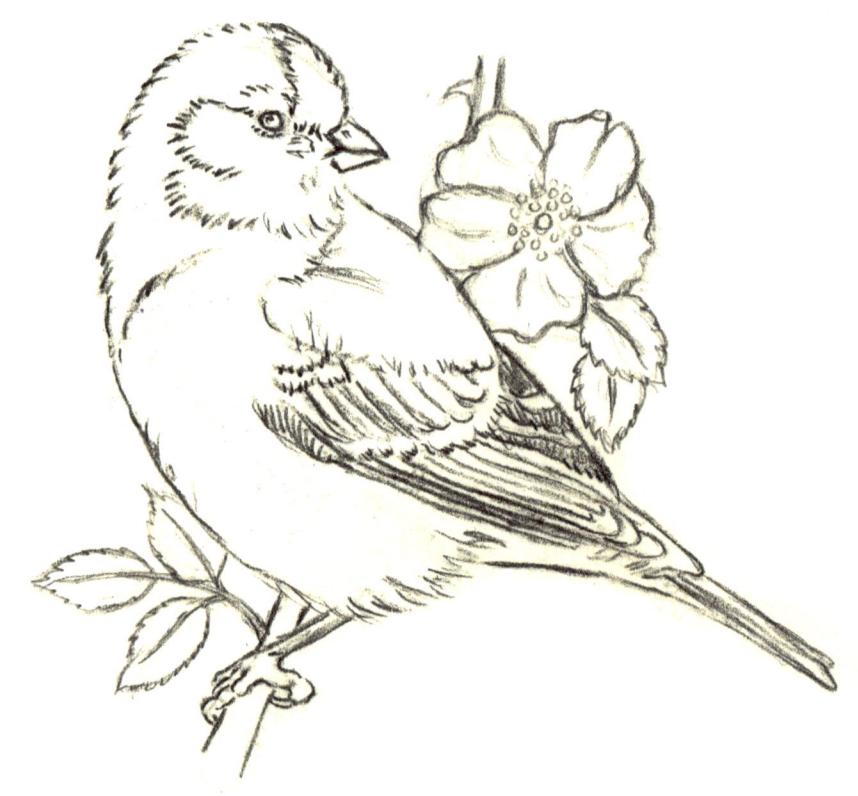

Use this page to transfer the image
over to your watercolor paper.

Goldfinch
Rose & Stem

Colors: Permanent White, Burnt Umber, Ultramarine Blue, Burnt Sienna, Spectrum Yellow, Olive Green, Ivory Black

(1) Using a dark value (Burnt Umber mixed with Ultramarine Blue), paint over your pencil lines so they won't be lost when you start painting the layers of gouache. Put a thin wash of this same gray color over the yellow rose, making it a little darker toward the center. Also paint the stem of the rose with Burnt Sienna.

(2) To finish the stem, use a very dark value of Burnt Umber mixed with Ultramarine Blue to paint the shadows. Add white to Burnt Sienna to add the highlights. Blend the colors together a little with a damp brush. Also use a damp brush to soften the outside edges so the stem won't look pasted on the paper. To finish the leaves use a mixture of Primary Yellow, White and a little Olive Green to paint in the lighter sections of the leaves. Blend and soften the outside edges.

(3) Mix Primary Yellow with a large amount of White and paint in the petals, leaving some of the gray underlayer showing, as in the illustration.

(4) With a damp brush blend the yellow into the gray of the shadows. Add pure White in areas to highlight parts of the petals. Make sure you almost cover the dark line on the outside edges of the petals.

Goldfinch Flower, Body, Head

(5)

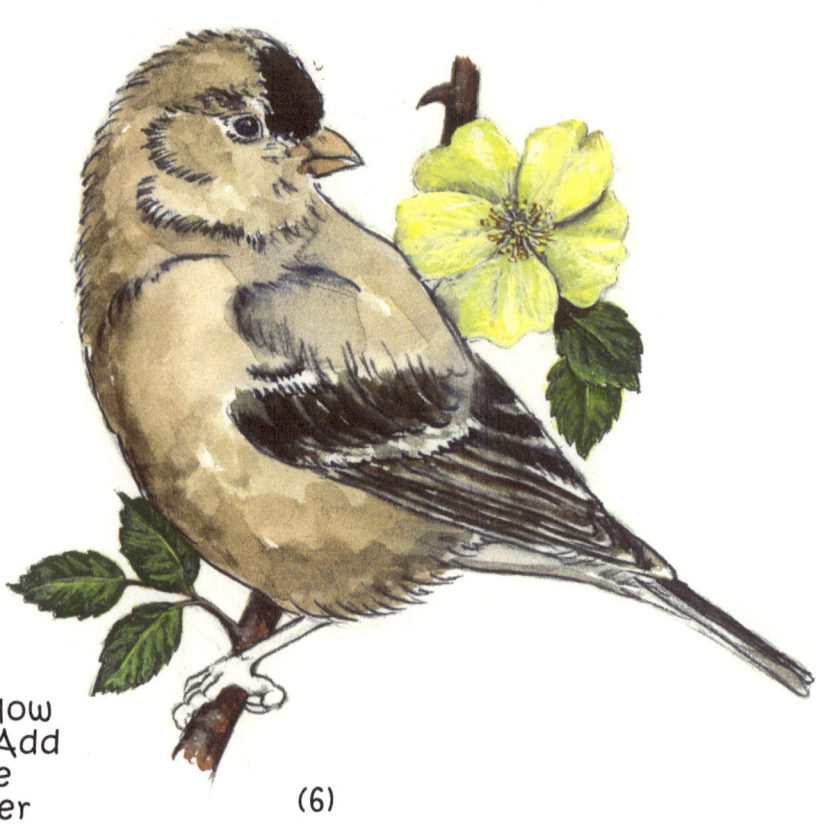
(6)

To finish the flower, paint lines of Burnt Sienna and then White mixed with a little Spectrum Yellow radiating out from the center. Add pale yellow dots and paint a little Burnt Sienna shadow on the lower side of the dots.

With a thin wash of Burnt Umber mixed with Burnt Sienna, cover up the white on the Goldfinch. Vary the value (lightness or darkness), making the patch on the head and the wings very dark, still being careful to not paint over all your lines. Also make the bird a little darker on the left side and under the belly since those parts are in shadow.

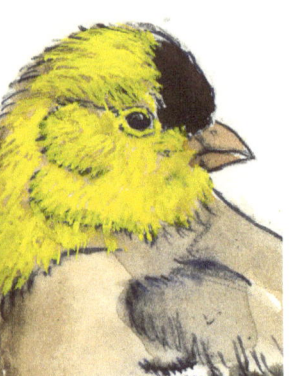
(7)

Using Spectrum Yellow, paint short strokes on the head, going in the direction of the feathers.

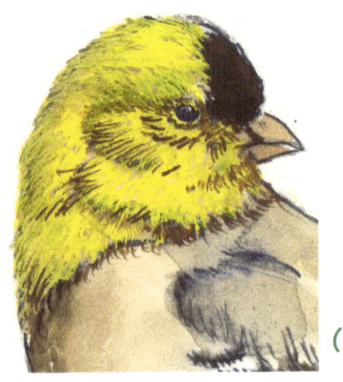
(8)

Strengthen the shadows on the head with a mixture of Burnt Umber and Burnt Sienna.

22

Goldfinch Head

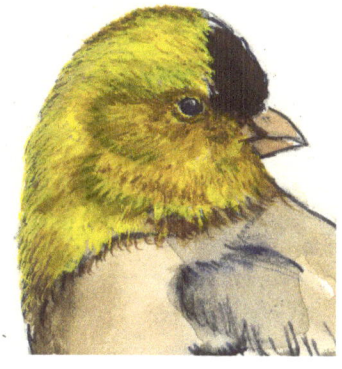

(9)

With a damp brush, gently blend the yellow into the brown color.

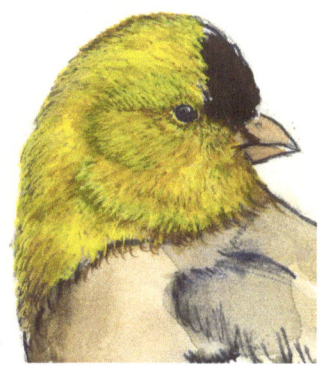

(10)

For the final layer, add a little white to Spectrum Yellow and paint more short strokes in the direction of the feathers. Be sure to lift up at the end of each stroke to make a fine point, and don't completely cover the layer below. With a damp brush blend a little.

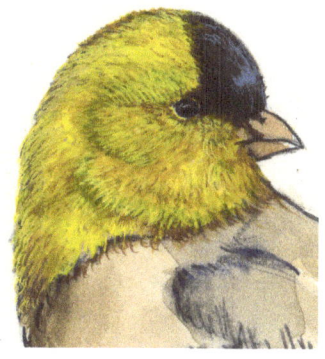

(11)

With Black, paint short strokes over the dark value on the forehead that you painted previously. With a damp brush, soften the edge where the black meets the white paper so it doesn't look pasted on the page. Highlight the forehead patch with White mixed with Ultramarine Blue and blend it in.

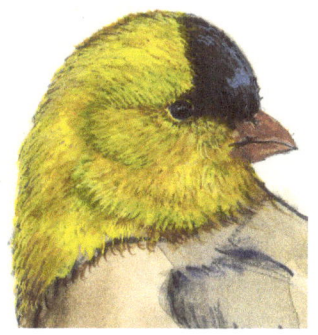

(12)

Beak -- Paint the beak with a mixture of Burnt Sienna and White.

Goldfinch Beak and Foot

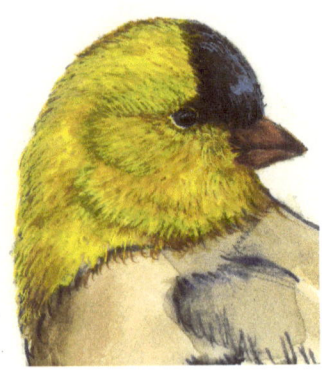

(13)

Use Burnt Umber to add the darkest values to the beak.

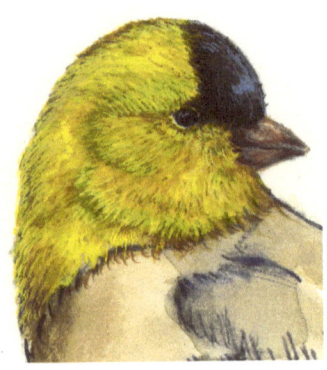

(14)

To finish the beak, use White with a tiny bit of Burnt Sienna to add highlights. Blend with a damp brush.

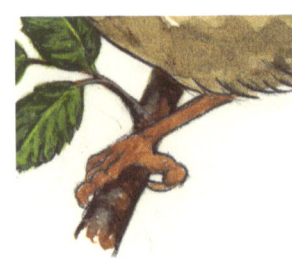

(15)

Using White mixed with a little Burnt Sienna, paint the foot.

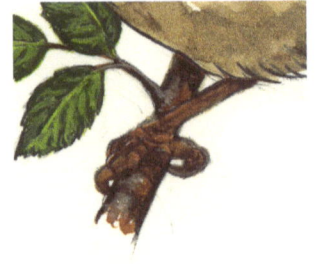

(16)

With Burnt Umber, detail the foot. Use a damp brush to gently soften the lines.

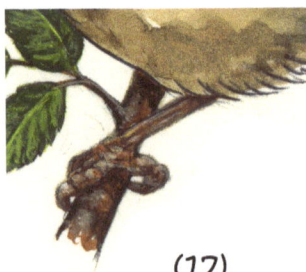

(17)

With White tinted with a touch of Burnt Sienna, paint the highlights on the toes and leg. Blend gently with a damp brush.

Goldfinch Body

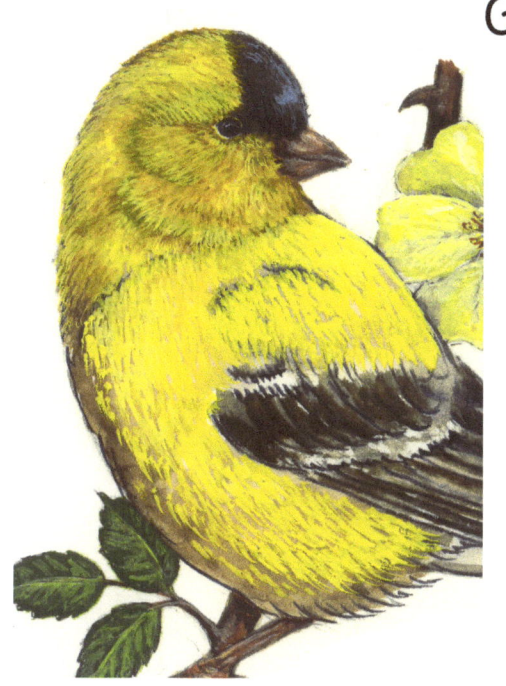

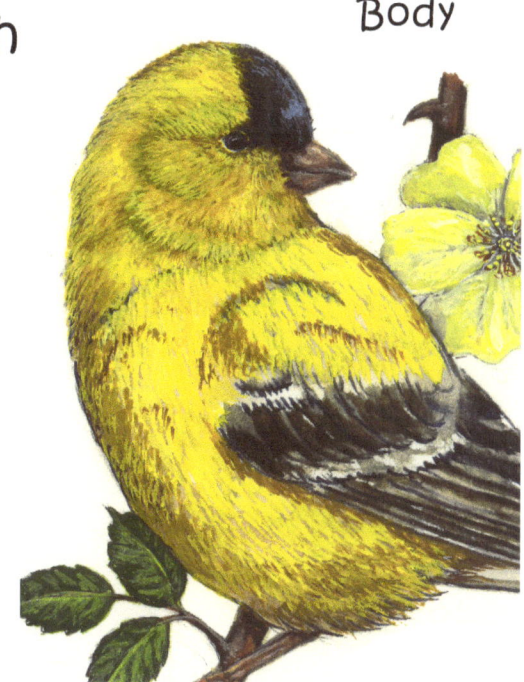

(18)
Use pure Spectrum Yellow to paint short strokes on the body, being careful to go in the direction on the feathers. Don't completely cover the darker layer underneath.

(19)
Add a mixture of Burnt Umber plus Burnt Sienna to Spectrum Yellow and paint the shadow areas on the body. Remember to use short strokes in the direction of the feathers.

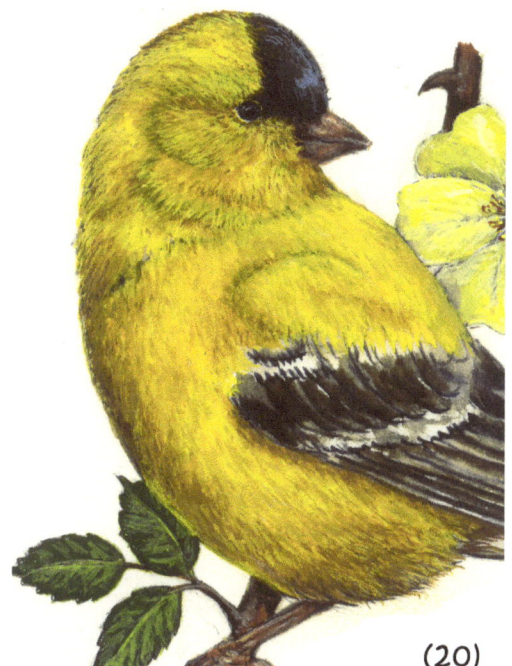

(20)
With a damp brush, gently blend your strokes toghether. Blend the yellow into the brown in the shadows. Don't completely cover up the darker colors in the layers underneath. Paint white highlights on top of the shoulder. Blend it in so that it will turn very light yellow.

Goldfinch

Tail

(21)
Using a mixture of Burnt Umber and Ultramarine Blue, paint the underside of the tail.

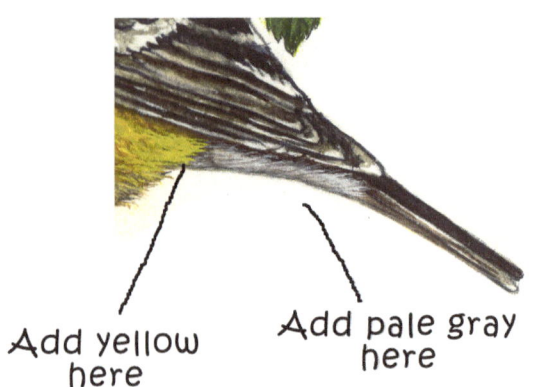

Add yellow here

Add pale gray here

(22)
Using a pale gray mixture of mostly White with a little of the Burnt Umber plus Ultramarine added, paint the light colored feathers under the tail. Also use Spectrum Yellow to paint feathers over the beginning of the tail where the white begins. Blend your strokes.

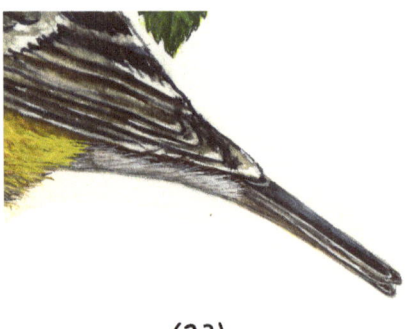

(23)
Use White to paint in the edges of the tail feathers. Also, mix Ultramarine Blue with White and paint a highlight on the top edge of the dark tail feathers. Blend it so that it can barely be seen.

Goldfinch Wings

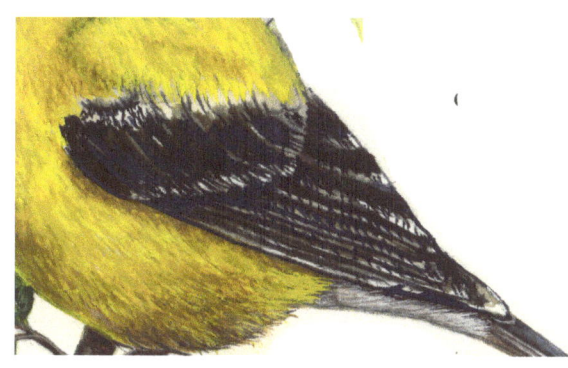

(24)

Using a very dark value of Burnt Umber and Ultramarine Blue, restate the darks in the wing.

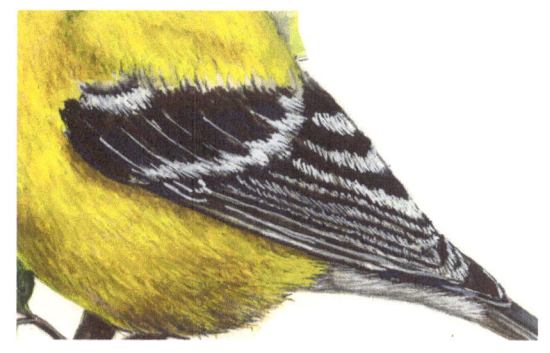

(25)

Using pure White, highlight the tips and edges of the wings.

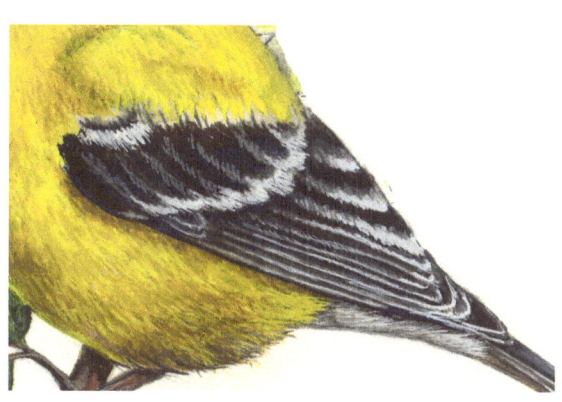

(26)

Starting with the lower wing feathers, blend the darks into the lights. As you go along some of the white or dark will be lost. Just paint in the white or dark again and blend.

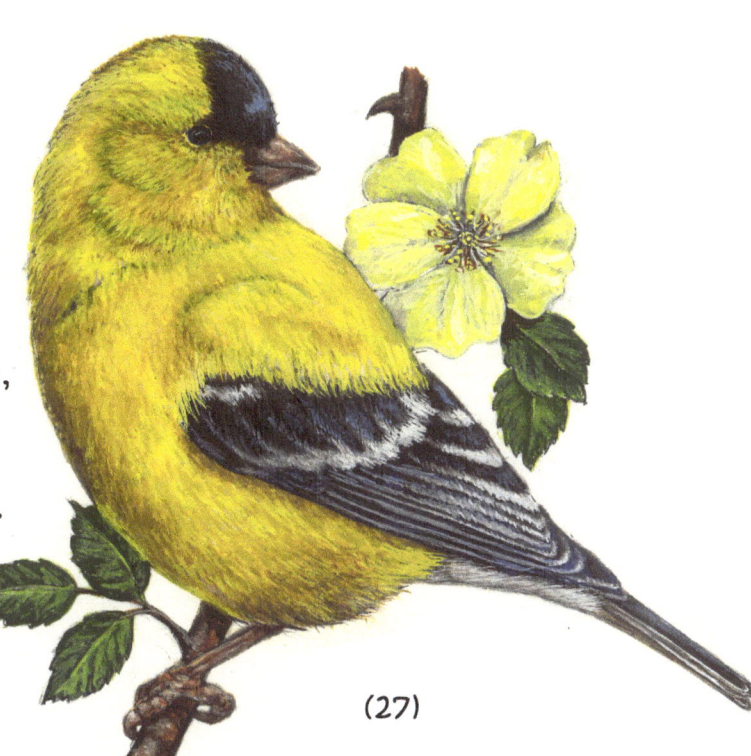

(27)

This is a back and forth process. Repeat putting in your lights and darks and blending until you've defined the wing feathers. When you have them finished use Spectrum Yellow and paint short strokes down from the back of the bird and over the top of the wing. Blend lightly.

. . . and you're done!

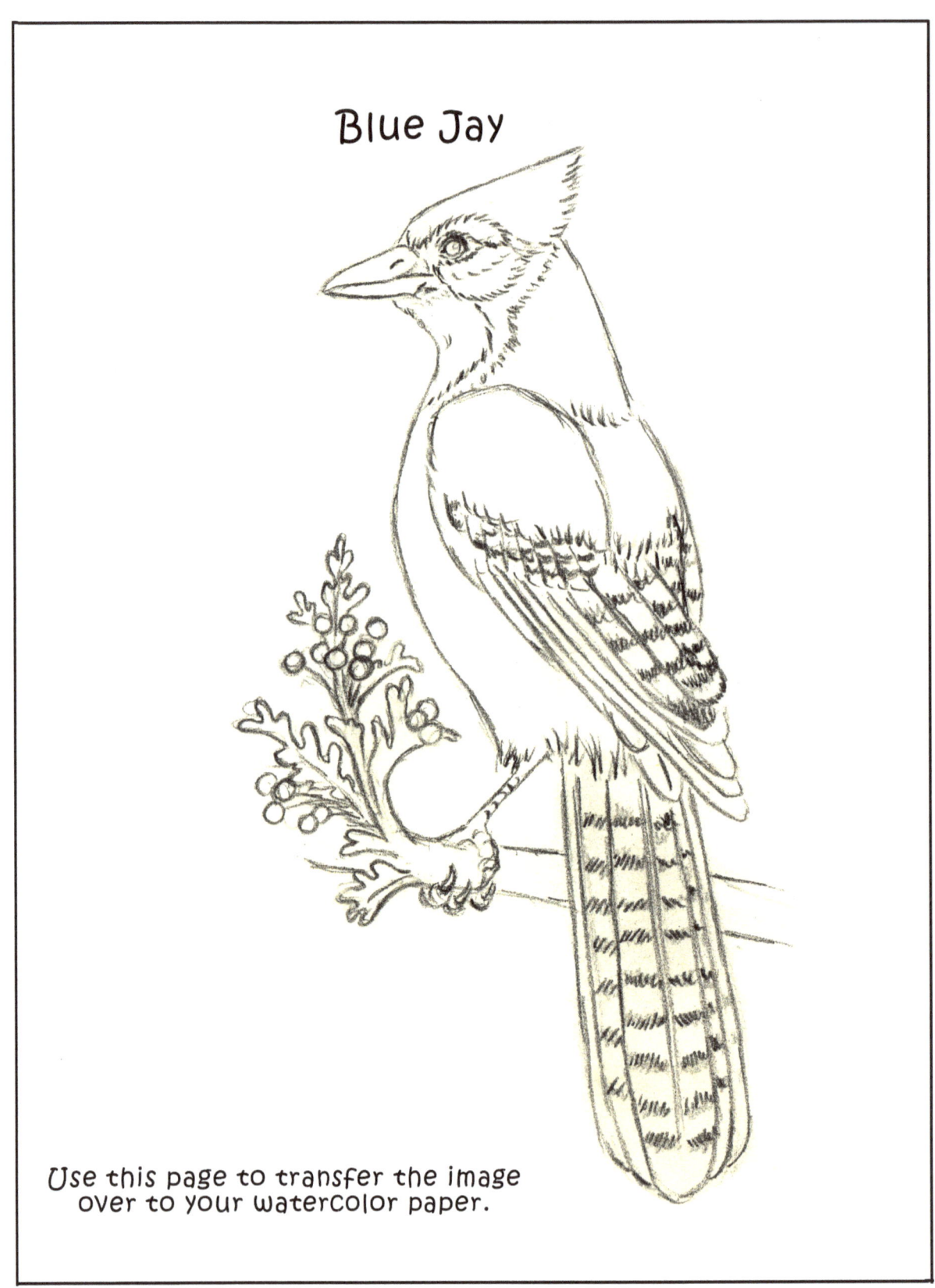

Blue Jay Branch & Juniper

Colors: Permanent White, Burnt Umber, Ultramarine Blue, Primary Blue, Spectrum Yellow, Olive Green, Ivory Black

(1)
With Black, paint over your pencil lines so they're not lost when you begin painting layers of gouache. Look at the head carefully and paint in the black areas. With a dark mixture of Burnt Umber and Ultramarine Blue, paint in the dark portion of the branch. With Spectrum Yellow mixed with Olive Green paint in the juniper.

(2)
With a medium value of White mixed with Burnt Umber and Ultramarine Blue, paint over the remaining white spots on the branch. Mix Olive Green, Spectrum Yellow and White to make the highlights on the juniper. Dot the paint on. Paint the shadows on the juniper with a mixture of Burnt Umber and Ultramarine Blue. Blend both the branch and the juniper. Be sure to soften the outside edges.

29

Blue Jay — Juniper & Body

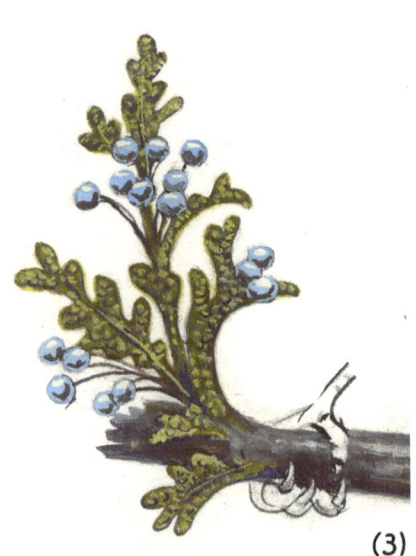

(3) Mix Primary Blue with a little White and paint the berries. Use Ultramarine Blue mixed with a little Burnt Umber to paint the shadows. Use White to highlight the upper side of the berries.

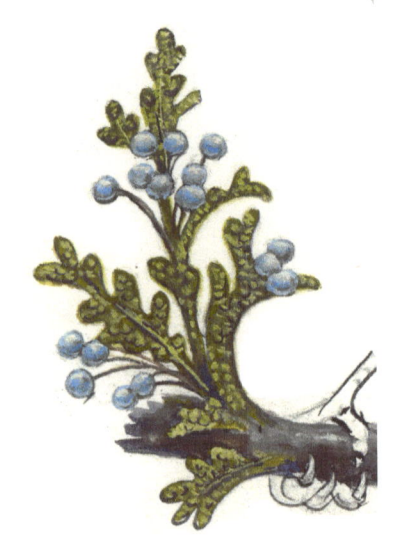

(4) With a damp brush blend the areas together. Use just a touch of Primary Blue and White to paint reflected light on the underside of the berries. Blend.

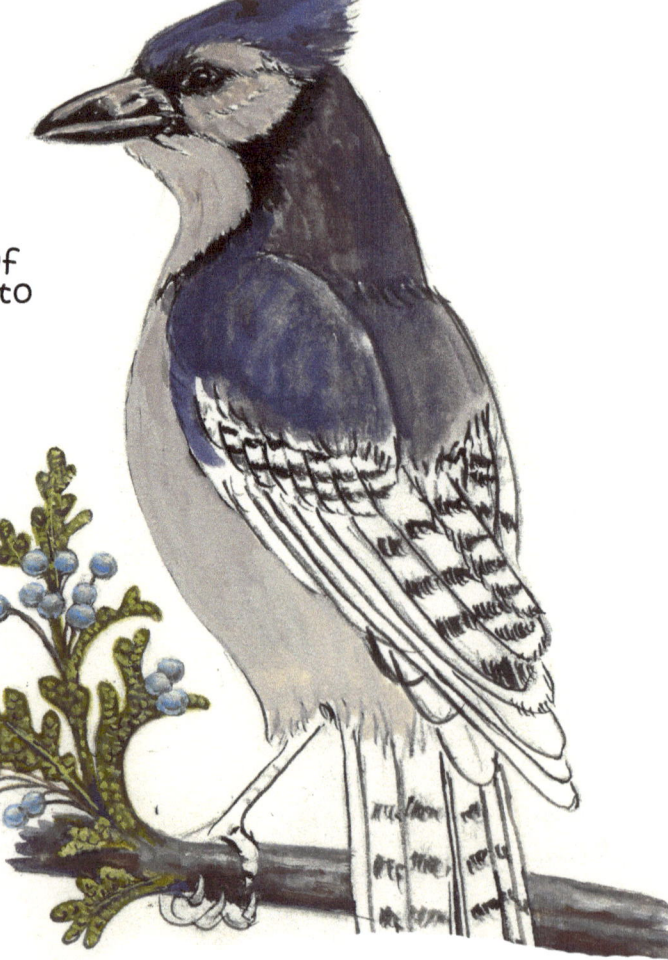

(5) With White tinted with a mixture of Burnt Umber and Ultramarine Blue to make a medium gray, paint the underpainting on the white parts of the Blue Jay's body and head. Use Ultramarine Blue mixed with Burnt Umber to paint the underpainting on the blue areas of the Blue Jay's head, neck and shoulders. These bottom layers can be of a thinner consistency.

Blue Jay

Head, Neck & Shoulders

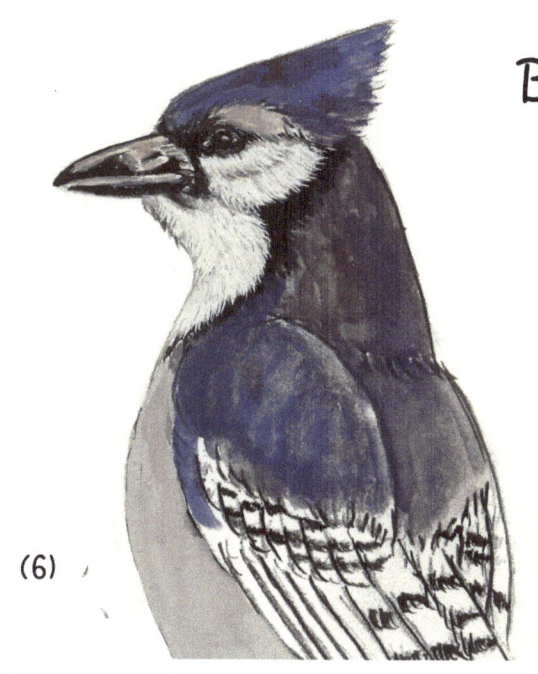

(6) With pure White, use short strokes to paint the white areas on the underside of the neck and below the eye. Gently blend the strokes together, letting some of the gray underpainting show through. Lift your brush at the end of the stroke to make a fine point, and stroke in the direction of the feathers.

(7) With White mixed with a little Primary Blue, paint the peak using short strokes going in the direction of the feathers. Blend. Try not to blend so much that you make an even tone. If you do just add more light blue or Ultramarine Blue and blend again. You'll want to add a few white strokes for highlights and a few strokes of Ultramarine for shadows..

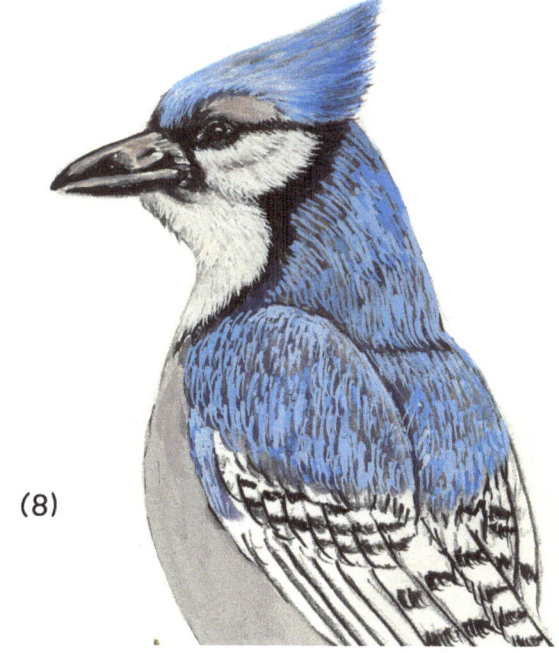
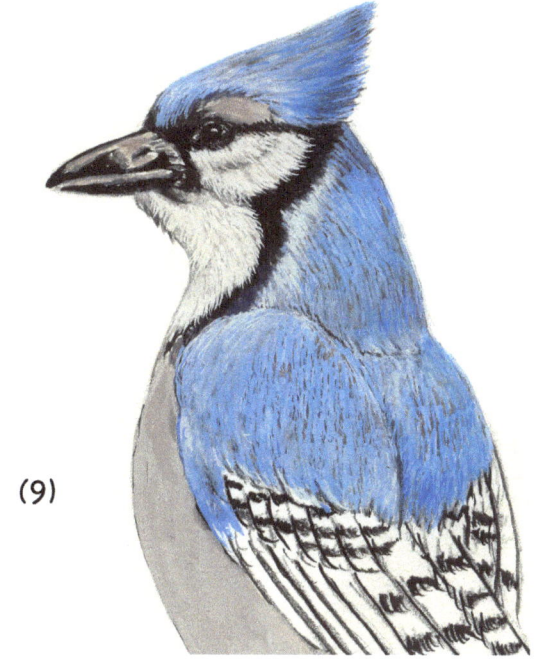

(8) Continue using light blue to paint short strokes on the back of the neck and the shoulders.

(9) Keep adding more light blue strokes. Look carefully at the variances in color in the neck and the shoulders. Add more white in the lightest areas and a little Ultramarine Blue mixed with Burnt Umber in the darker ones. Make your strokes follow the curves of the bird's body. Blend carefully.

Blue Jay

Head, Necklance & Beak

(10)

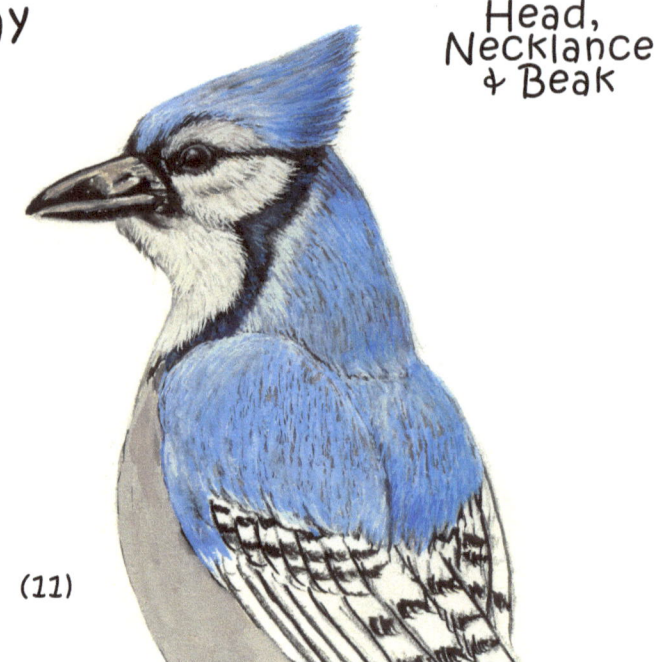
(11)

With pure Black, paint in the eye. With a light gray (White plus a touch of Burnt Umber and Ultramarine Blue), paint the rim around the eye. Note that the color varies a little. Put a light gray highlight in the eye and blend it in a little. Then use pure white to put a highlight on top of that but just barely blend it to give it some sparkle. With pure White, paint the white patch over the eye and blend the strokes a little with a damp brush.

Necklace -- With Primary Blue tinted with White, paint short strokes of highlight along the necklace so it's not just pure Black. Blend a little. You may have to add the blue and blend several times.

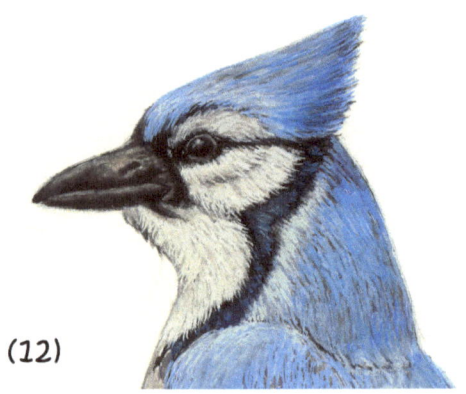
(12)

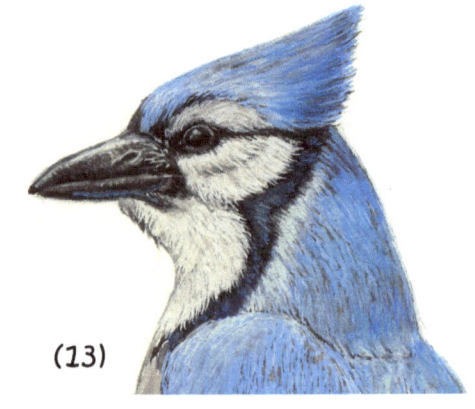
(13)

Beak --This next step will be done using only water. You previously roughed in the beak with black gouache. Now, with a damp brush, blend the black, remembering to soften the outside edges so the beak won't look pasted on the paper.

With White, highlight the beak and gently blend it in with a damp brush. Use Primary Blue mixed with a little white to paint reflected light on the underside of the beak. With pure white paint in the small white feathers around the base of the beak, the ones pointing forward.

Blue Jay Foot & Tail

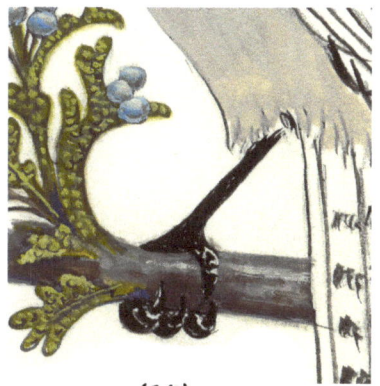

(14) Foot -- Use Black to paint in the Blue Jay's foot. Leave a few white places so you don't entirely lose the contours of the toes.

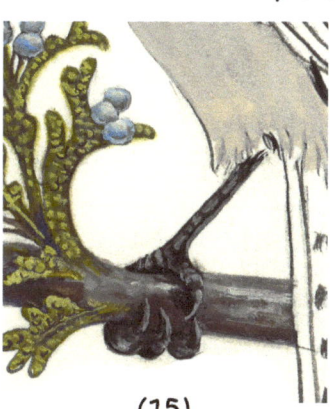

(15) Using light gray (mostly White with a touch of Burnt Umber and Ultramarine Blue), detail the foot as shown. Use a lighter value of gray than you think you'll need, because when you blend it in it will become darker.

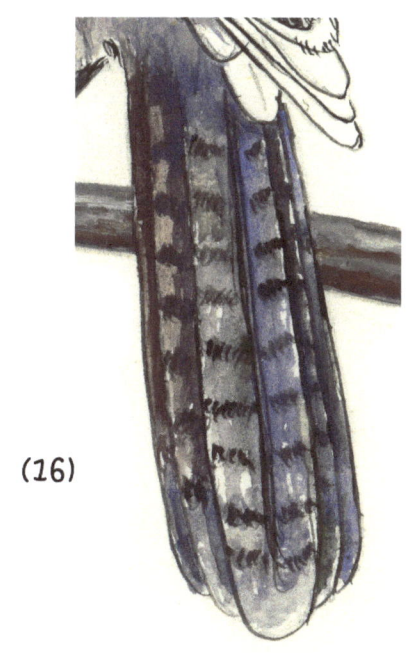

(16) Tail -- Paint the tail with an underpainting using a mixture of Ultramarine Blue and Burnt Umber. You can add a bit morre water to the gouache and make this a thinner layer. Don't worry about getting everything exact.

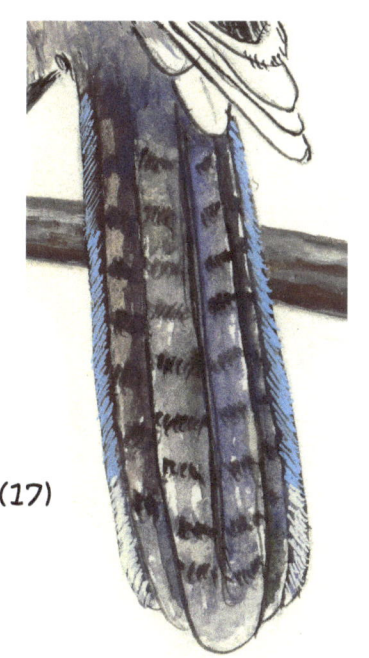

(17) Finish the two outside feathers first. With a mixture of White and Primary Blue, make diagonal strokes pointing downward along the edges of the two outside feathers. Toward the bottom use pure white.

Blue Jay Tail

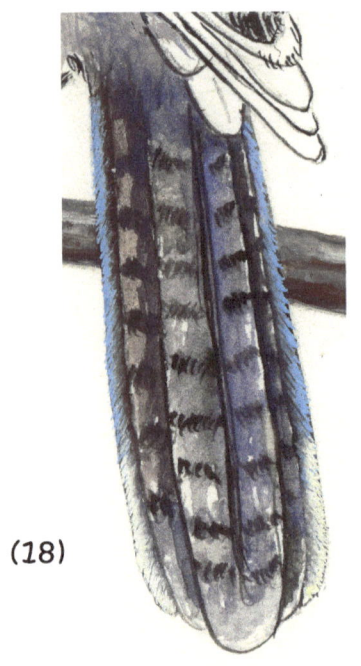
(18)

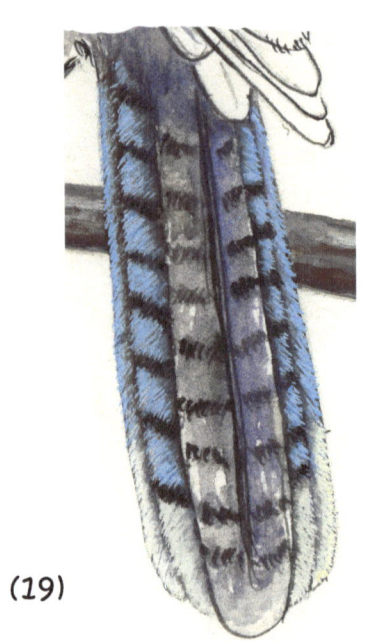
(19)

With a damp brush, carefully blend the lightest blue into the shadow area. You may have to add more light blue or white towards the bottom of the feather.

Now complete the 2 feathers on each side of the middle feather. Using Primary Blue mixed with White, make diagonal strokes pointing downward along the feathers. Blend. With pure Black paint in the black bars, again using short diagonal strokes pointing downward. Blend. You may lose your darks or lights in the blending process. Just repaint them and blend again. Soften the lines between the colors.

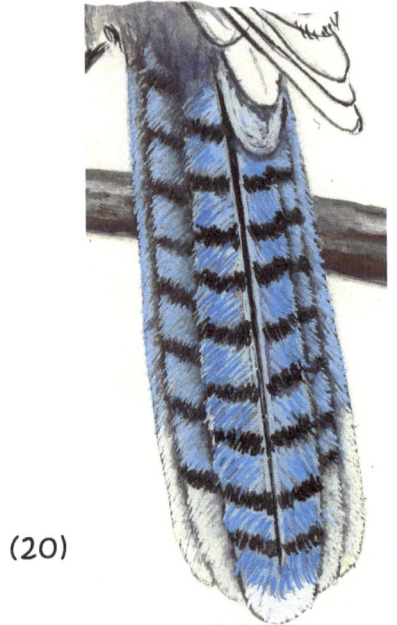
(20)

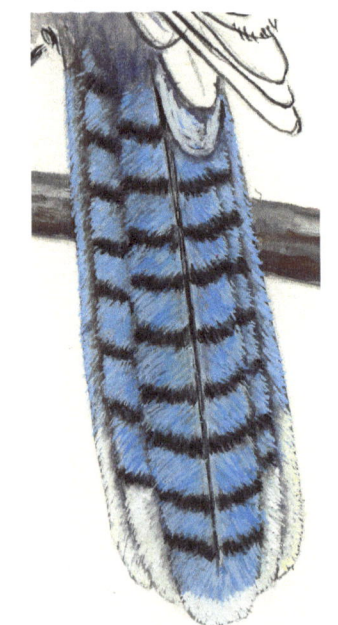
(21)

With Black, paint the main vein of the middle feather. With White tinted with Primary Blue, paint a line on each side of the black vein line. Then use White mixed with Primary Blue to paint short, diagonal strokes pointing downward along each side of the vein. Using Black, paint in the bars.

With a damp brush, going parallel to your brush strokes, slightly blend the strokes together. You'll need to add more black or blue as you go along, and then reblend. Paint the tip of the tail feather White. Paint a narrow white highlight on the main vein.

Blue Jay

Breast & Right Wing Tips

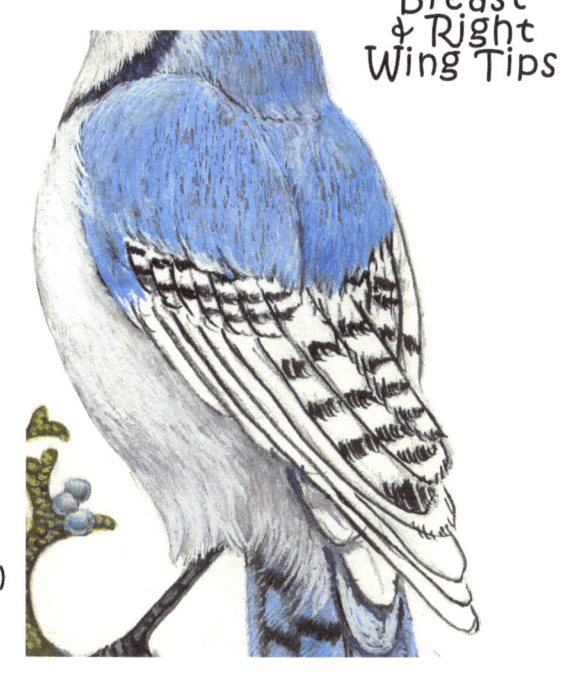

(22)

(23)

Using short strokes in the direction of the feathers, paint the breast with pure White, being careful to leave some of the underpainting showing through. As you get nearer to the leg, leave more and more of the underpainting untouched so that when you blend it will be darker. Blend the strokes a little to soften them.

With a mixture of White, Burnt Umber and Ultramarine Blue, shade the underbelly. Blend. Add more White strokes and blend again until you're satisfied that the form looks round. Also use White to add the lower right wing tip feather.

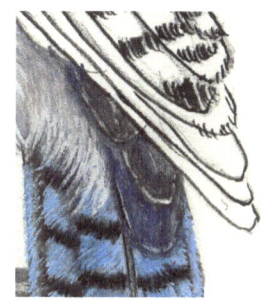

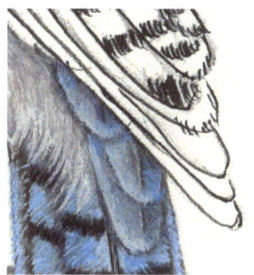

(24)

(25)

Right Wing Tips -- Paint the tips with a mixture of Ultramarine Blue and Burnt Umber.

With light blue (Primary Blue mixed with White), paint the veins in the three feathers. Using a middle value of blue (Primary Blue plus White), paint short diagonal strokes from the veins to the outside edges of the feathers. On the right side of the feathers use Ultramarine Blue to shade. Blend.

Blue Jay — Wings

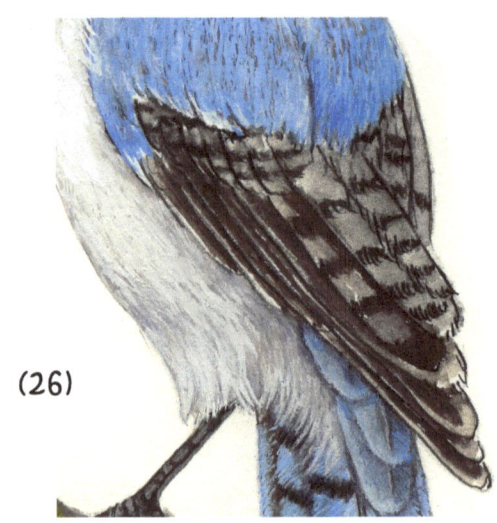

(26)

With a thin wash of Ultramarine Blue mixed with Burnt Umber, paint over the wing.

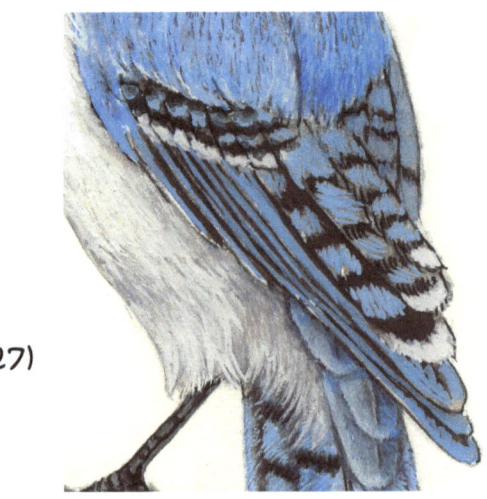

(27)

With a medium value (Primary Blue mixed with White), begin detailing the wings. Add pure White to the feather tips and the white bars. Don't worry about getting everything exact at this stage.

(28)

With a damp brush, shade the long wing feathers by blending the blue into the dark underlayer on the right side of the feather. On the left side of the long feathers, paint a strip of light blue. Blend.

Blue Jay

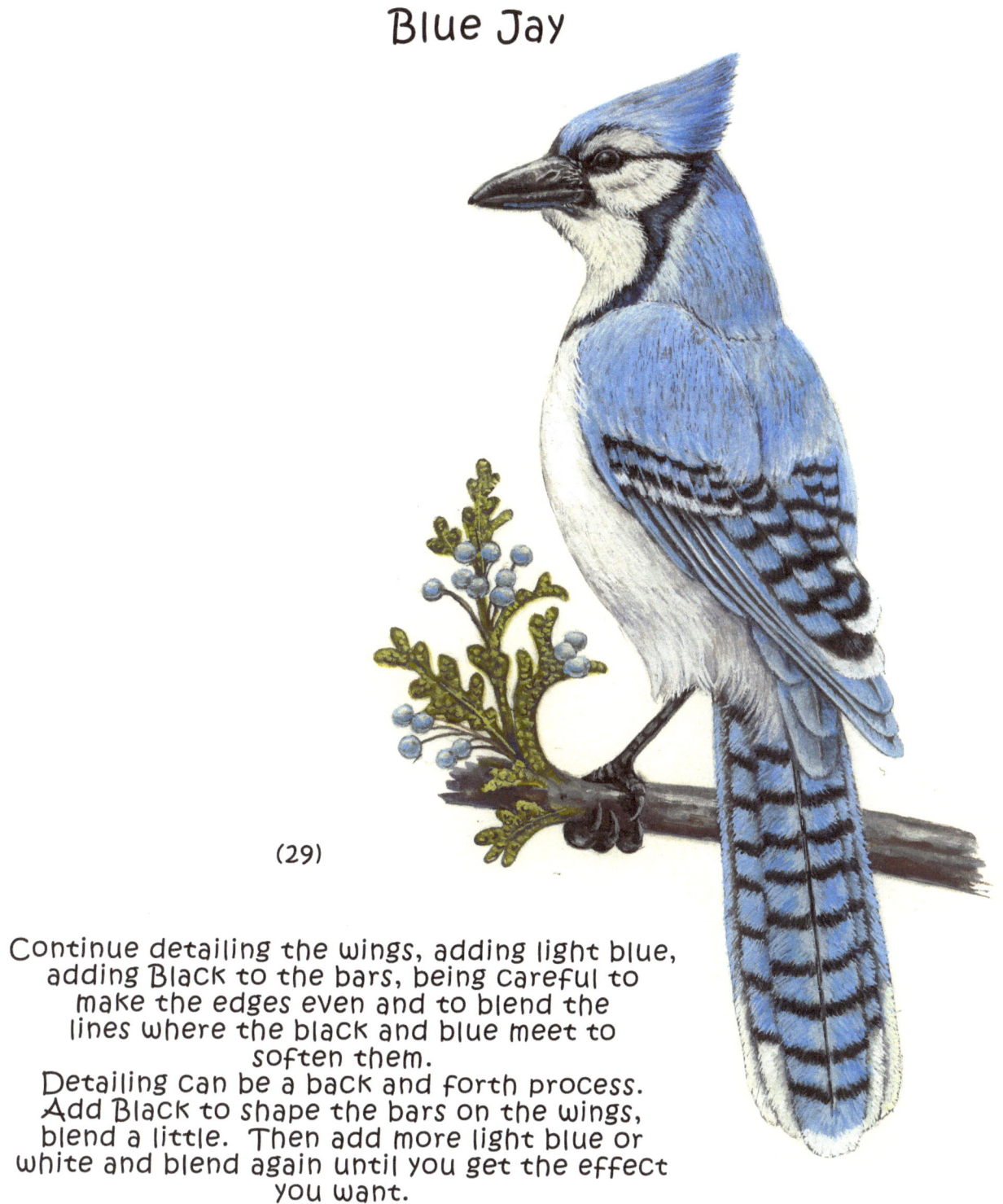

(29)

Continue detailing the wings, adding light blue, adding Black to the bars, being careful to make the edges even and to blend the lines where the black and blue meet to soften them.
Detailing can be a back and forth process. Add Black to shape the bars on the wings, blend a little. Then add more light blue or white and blend again until you get the effect you want.

. . . and you're done!

Notes

Wrapping Things Up!

Painting sharp eyes and colorful feathers is fascinating.
I hope I've inspired you to continue to explore all the possibilities
of using gouache to paint birds. An octogenarian friend of mine,
an accomplished artist, once told me that every time you pick up
a brush it's a learning experience. May you have many!

Please check back at Sound of Wings Studio, www.soundofwings.com, for upcoming courses in gouache!

Thanks!

Sandy

Sandy

Notes